ALICE
IN
ARTS ADMINISTRATION

BY

Ann Dunbar

Illustrations by Elizabeth Diggans

WOODCHUCK, PRESS
New York, NY

For
Dorothy

FIRST EDITION
Copyright 1986 by Ann Dunbar
Library of Congress Card No. 86-050755
ISBN 0-939855-00-3

Woodchuck Press
153 East 18th Street
New York, New York 10003

PRINTED IN THE UNITED STATES
OF AMERICA

Chapter 1

It was the best kind of autumn afternoon in the park. The sun was hot but a cool breeze made the grass ripple and the trees purr.

"Dinah would find that utterly absurd," thought Alice, looking down at the kitten curled up next to her. "She knows perfectly well trees can't purr."

They were sitting on the bank of a little lake, but Alice had grown weary of the book she'd brought to read and found herself gazing up at the buildings along the parkway and, beyond, at tufts of clouds floating in the pale blue sky.

"Rather like little lost tails looking for their rabbits," she thought sleepily.

Just then she heard a rustle in the bushes nearby and was quite astonished to see a white rabbit run out into the clearing. The rabbit stopped, took a watch out of his waistcoat pocket, looked at it, said very loudly, "Oh damn, I'm late again!" and hurried on.

Overcome with curiosity, Alice jumped up, upsetting Dinah's nap, and ran after him. She was just in time to see him pop down a large rabbit hole and, without thinking how in the world she would ever get out, Alice jumped in after him.

The hole was very deep and Alice found herself falling at such a rate, she began to worry about the landing. But, after a time, it seemed that she wasn't falling *down* but falling laterally.

3

"This is curious," thought Alice, and she began to worry less about the actual descent and more about where she might eventually land.

"Now if, indeed, I am falling across the earth *and* falling east, then I shall definitely end up in England. Oh, wouldn't that be grand," thought Alice. "I shall be able to visit the Queen, and won't Dinah be impressed with that! But if I am falling west... Oh dear, if I don't stop soon, I shall be all the way to China!" That seemed right, although Alice had never cared for geography and wasn't too sure where China really was. Then, with a gentle thump, Alice landed and her journey was over.

Finding herself not in the least hurt, Alice stood up and looked around. It was an amazing place with the strangest trees she had ever seen. At least she thought they were trees. They were very tall and the leaf part was only at the very top. But she had no more time to consider her surroundings because the White Rabbit was fast disappearing down a path, muttering, "Damn it, I am so late. I shall never get to my meeting on time."

Alice ran like the wind until she finally caught up with him. "Oh please, sir, excuse me, but can you please tell me where I am?"

The White Rabbit stopped and glared at Alice. He took his pocket watch out and pointed at it. "It's not where you *are* that matters. It's where you *should* be." He turned to run off again, but Alice got hold of the sleeve of his jacket and held on.

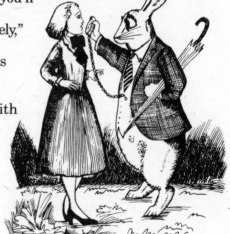

"I'm sure you're right and if you'll only tell me where I should be, then I shall go there immediately," she pleaded.

The White Rabbit yanked his arm away from Alice, held the watch in front of her nose and said sternly, "Tea time." And with that, he was gone.

"Oh dear," thought Alice. "He's quite right. It *is* tea time." So there was no time to lose and Alice hurried faster down the path.

After a short time, she came to a clearing and there, surrounded by those odd trees, was a large pink building. A long walkway led to the front door, and at the end was something that looked like grass but turned out to be green carpet.

"Imagine that," she said aloud to herself as she gingerly stepped on it and walked up to the door. It opened just as she reached it. Standing in the doorway was a tall footman, looking rather like a frog. She had never seen a frog-footman before, nor anyone so tall. Then she thought, "Either he is very tall or I have gotten very small." (And indeed, she was feeling as small as she ever had in her life.) He looked down at her expectantly, so she said, in a voice as tiny as she felt, "My name is Alice."

"Oh yes, they're expecting you," the footman said. "Follow me."

Alice did so and was quite relieved when she saw a little sign that read: *Polo Lounge*. "Well," she said to herself, "at least I know I'm in England. That's a start."

After following the footman for what seemed an awfully long way, Alice was ushered into a kind of garden, in the middle of which was a long table. It was set for six, but only four of the places were taken. "This is Alice," said the footman, and everyone stood up except the woman at the head of the table. He gestured toward her: "The Duchess." The Duchess nodded at Alice. "The Knave, Tweedledee and Tweedledum." Each bowed as his name was called.

"I'm sorry I'm late," said Alice.

"No time for apologies," said the Knave. "Just sit here next to me. The White Rabbit was due, but he couldn't come." Once Alice was seated, the others followed suit, and then all turned to look at the Duchess. She began to speak.

"Alice dear, if you are to be the Executive Director of our Orchestra Association, there are a number of things you should know. First, I am the President. The White Rabbit is Chairman of the Board. He wasn't always Chairman. The Gryphon was, for a long time. Let me see. I was Chairman before that, and that was eight years ago, and the Gryphon was Chairman until last year, so that would make it...."

Alice subtracted one from eight and wanted to say, "Seven," but everyone else was quietly waiting for the Duchess, so Alice did, too. Finally the Duchess spoke again.

"Seven years. Yes, that's right. And during that time, his family gave the Orchestra a great deal of money. But last year, the Gry-

phon disagreed with a decision of the Council so he and all his friends resigned. Without them, we didn't have enough money to finish the season, so we had to borrow from a bank."

"Oh dear," thought Alice, and she was about to ask why the other Board members didn't help, when the Duchess continued.

"Now, Mouse works in the office. She has worked in the office for the last.... Now let me see...." The Duchess began counting on her fingers, and Alice tried not to look impatient. "Twelve years. She doesn't know you're here, but we'll tell her before you go in to work. We love Mouse. We want you to know that. But it's your office and we'll understand if you want to let her go. There probably isn't enough money to keep her anyway. The Mad Hatter," she went on quickly, "is the Founder. That was...uh...twenty years ago. He's still the Founder but hasn't had anything to do with us since we threw him out...." The Duchess paused to consider how long that had been.

"My, she's precise with numbers," thought Alice.

"...six years ago. He's a barracuda and he is out! O-U-T! If you should meet him, you're to have nothing to do with him. Is that clear?"

The Duchess glared at Alice, who nodded, thinking, "The answer is clear. The question is how?"

"The Knave here is the Treasurer. Tweedledum is Chairman of the Funding Research and Financial Improvement Committee. Tweedledee doesn't have a title. Humpty Dumpty is Chairman of the Council." Alice must have looked puzzled, because the Duchess explained, "The Council makes the artistic decisions. The Board makes the policy decisions, but anything the Council wants must be approved by the Board if it costs money."

"Oh dear, almost everything costs money. How do they decide who decides what? And what does the Conductor decide?" wondered Alice.

"Now there's one other thing you should know. Five years ago, we joined the Performing Arts Union. It seemed like a splendid idea at the time, to be affiliated with a much larger organization, but it didn't work out. We couldn't do any independent fund-raising, they took a percentage of what we earned, it cost a great deal of money, and we've been going downhill ever since." The others nodded gravely. "But," said the Duchess, brightening, "you're here now!"

And, as if that summed up everything, they all stood and

6

walked away, leaving Alice sitting alone, shaking her head, saying, "Oh dear, oh dear."

On her first day, Alice telephoned the office to tell Mouse she was on her way, hoping that by then Mouse was expecting her, but a little girl answered. "Who are you?" asked Alice.

"I'm Dinah, I'm the secretary."

"Oh my," said Alice, "they didn't tell me about you." "Isn't that queer?" thought Alice, as she hung up, "I hope she's as sweet as my Dinah."

When Alice got to the office, she found the Knave waiting with Mouse. He introduced everyone all around, and left Mouse to show Alice the office rooms. Mouse offered to give up her room if Alice liked it, but Alice thought she'd be quite happy in the one planned for her, once it was neatened up a bit. Then Alice and Mouse sat down, and Mouse began to tell Alice all about everything. Not much of what she said made any sense, but Alice listened and listened. By mid-afternoon, she felt like a force-fed goose, and wanted nothing more than to sit down in the middle of the floor of her new office to have a good cry. "But Executive Directors don't cry," she reminded herself sternly. And she couldn't complain, because Mouse was being so kind and trying to be helpful when, with some justification, she might easily have resented Alice terribly. The clock finally struck, and it was time to go home.

The next day, Alice eagerly began to get organized. The concert season was about to begin, but there were still subscribers who hadn't renewed so Mouse was about to send out a reminder. It was the same as the first one she had sent and a second she had sent later (stamped "Second Request"), but she planned to add a handwritten note to this third one. Instead, Alice composed two letters, one to the renewed subscribers announcing her own arrival and saying how much she looked forward to the year ahead, and a second one urging those who hadn't renewed to act soon. The letters would be printed with space for Dinah to type in the names, addresses and salutations.

Dinah didn't type very fast, nor could she take dictation. She was, however, going to secretarial school and Alice was relieved to find that she was as smart as she was sweet. "*Quite* like my Dinah," thought Alice.

In evaluating some of what ought to be done, Alice decided that

new stationery was needed. What they had been using didn't have the masthead required by the by-laws, and she wanted to add her name and Mouse's. Tweedledum came for a meeting to discuss raising money, which Alice knew was one of their highest priorities and, later in the day, she prepared for the next morning's meeting with the White Rabbit.

The White Rabbit agreed to everything Alice suggested, except putting Mouse's name on the new stationery. He made it clear that as soon as Mouse had told Alice everything she needed to know, Alice should get rid of her. "Oh dear," said Alice, "there's so much to be done, I'm not sure I can get along without her."

"Do the best you can. We'll meet again next week and you can report how things are going." And he was off for another meeting.

Alice felt it was none too soon to get a grasp of the Orchestra's finances. She asked Mouse to go over the previous year's financial statement with her and they compared it to the budget approved by the Board for the current year. She was astonished to find that a sizable surplus was projected, although the prior year, as the Duchess had said, a large bank loan had been required to meet expenses. In the first place, Alice knew that one *never* estimates a surplus. In the second place, what was the source of all that money? After careful review, she determined that the expenses estimate was about right. "But Mouse," said Alice, "where is the income to come in *from?*"

Mouse shook her head. "I don't know. It's the White Rabbit's budget."

"But you've been here twelve years," persisted Alice. "Does this look right to you?" Mouse shook her head again. "Oh dear," thought Alice.

Alice had begun to explore. In corners and in drawers, she found stacks of papers, unanswered letters, unfiled correspondence, and piles of files, all dating back months and, in some cases, years. There seemed to be 200 extra copies of everything that had been printed in the last ten years; it was enough scratch paper to last the next ten. It couldn't all be blamed on Mouse. She had only been the assistant to a succession of managers and volunteer project administrators. But Alice realized this was no time to worry about the past.

The Duchess was planning a welcoming party for Alice, to which she was going to invite the members of the Board and the Council.

Alice printed a letter from the White Rabbit, as Chairman, which Dinah, taking time from the renewal letters, was to address individually. Alice planned to forge the White Rabbit's signature to each. She hoped, by all the special letter-writing, to correct what seemed to be two major complaints: "Nothing is personal" and "No one ever knows what's going on."

There was no season announcement, so Alice was beginning to think about that, when she came across the most curious thing: the name of the Orchestra had recently been changed. It had had one name for nineteen years, and was well-known by it, but now the name was something quite different. "And it's not an improvement!" Alice told Mouse emphatically. Alice spent the rest of the day calling each member of the Board to get the name changed back again. "Oh dear," thought Alice when she learned that none of them could remember who had suggested the change in the first place, or why.

The following Monday morning, Alice arrived at the Tweedledee home to meet with the Duchess, the White Rabbit and several irate members of the Birds, the ladies' auxiliary. She was met at the door by Tweedledee's wife, who didn't know who Alice was or even that she was coming.

"If you please, ma'am, my name is Alice, and I'm the new Executive Director," Alice said. She was then ushered in to lunch. Six of the Birds were there, including Magpie who seemed the most irate of them all. She had even brought a tape recorder to document the proceedings. The Birds felt that they "didn't know what was going on" and demanded to be told. They most particularly wanted to know why the Gryphon had resigned, which meant that his sister, who was president of the Birds, had also resigned.

The Duchess sat at the head of the table and held forth at what Alice was coming to expect was her customary length. Then the White Rabbit took over to speak about the Gryphon, first asking that the tape recorder be turned off. (He hadn't wanted it on in the first place but the Duchess had cajoled him into it.) Magpie did so reluctantly, even though the White Rabbit said nothing which Alice felt couldn't have been repeated to the Gryphon's face, if necessary. At the conclusion of the meeting, Alice was asked to speak. She did so, stressing the importance of working together and the fact that the backbone of any orchestra is its volunteer Birds.

The meeting had gone on for over three hours, and it seemed the Birds had been pacified. The Duchess and the White Rabbit left. Alice was told to wait while the Birds met privately; after the meeting, one would take her back to the office. She was led into another room and, even through closed doors, Alice could hear their angry voices. "Oh dear," she thought, "they're not pacified at all."

That evening, Alice attended her first meeting of the Council. The purpose of the meeting was to discuss a revision of the guidelines for the Youth Concert Program, based on the recommendations of one of their most respected members who, unfortunately, was absent. The only person Alice knew was the Duchess, who introduced her to Humpty Dumpty.

"How do you do?" said Alice, politely.

"I don't," said Humpty Dumpty, bringing the meeting to order with a sharp bang of his gavel.

It was only the first in an evening of confusions. The presentation was in three parts. The first part presented the assumptions on which the recommendations were based, the second was the project itself, and the third discussed methods of implementation. It all seemed quite clear to Alice, but the first two hours were spent with everyone arguing back and forth, attacking the assumptions, and "striking them"—from what, she wasn't at all sure.

"Excuse me," said Alice, "but don't you think...?"

"Overruled!" snarled Humpty Dumpty. So Alice returned to her minutes-taking, which seemed to be the only reason she was there.

Next, the group made mincemeat out of the actual project guidelines, changing every single point recommended. "Oh dear," thought Alice, as she realized that the implementation was next in line for major surgery. When they had completely changed the recommended program and created another, they voted to send the author a letter of thanks. "How perfectly absurd," thought Alice. "The only thing everyone agreed on was the thank-you letter."

It was very late, but Alice decided to sit outside for a while, to see if she could gather her thoughts, so she wandered out into a little garden. Gazing up at the stars, she saw what appeared to be a large grin slowly emerge out of the darkness just above a tree branch over her head. Alice watched as the smile grew brighter, followed by two green eyes which were soon surrounded by a big, striped cat.

"How are you getting on?" asked the Cat.

"Oh dear," said Alice, "I don't think I'm getting on at all. Tonight they quarreled so dreadfully, and they don't seem to have any rules in particular. Or if they do, no one pays any attention to them."

"How do you like Humpty Dumpty?" asked the Cat in a low voice.

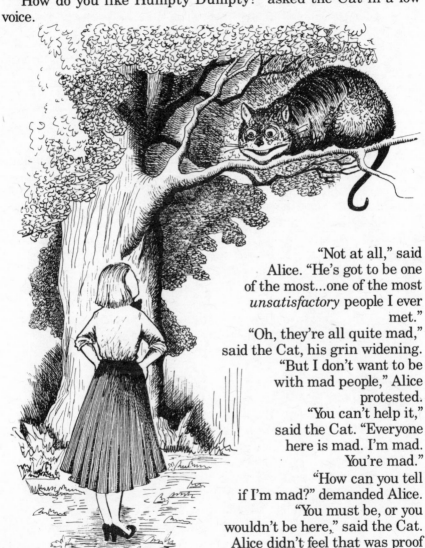

"Not at all," said Alice. "He's got to be one of the most...one of the most *unsatisfactory* people I ever met."

"Oh, they're all quite mad," said the Cat, his grin widening.

"But I don't want to be with mad people," Alice protested.

"You can't help it," said the Cat. "Everyone here is mad. I'm mad. You're mad."

"How can you tell if I'm mad?" demanded Alice.

"You must be, or you wouldn't be here," said the Cat. Alice didn't feel that was proof

at all, but had to admit there was a certain logic to it.

"What do you do here?" she asked.

"Oh, this and that, whatever needs doing, whatever they want me to do, but as little as possible. I'll be around," said the Cat airily, and he disappeared.

Alice stared up at the spot where the Cat had been and thought, "He may be mad, but at least he's friendly."

The next day, the Caterpillar telephoned Alice. He had been engaged as the Conductor for the season.

"I'm anxious to meet with you to finalize plans for the year," he said. "May I see you this afternoon?"

"That would be wonderful," replied Alice. "I've been looking forward to it."

When they met, he sat in Alice's office, puffing on a long thin pipe, and listening while she told him what she had been doing. From time to time, he would take the pipe from his mouth to say, "Quite right," and then resume smoking. When Alice finished describing the soloists who had been selected at the previous year's competition, she said, "I think all that remains is to decide on the repertoire. It must be approved by the Council."

The Caterpillar took a long drag on his pipe and exhaled the smoke in a solid stream which curled toward the ceiling. "Whooo are they?" he asked.

"They make the artistic decisions," said Alice. "Humpty Dumpty is their Chairman."

"Quite *wrong*," said the Caterpillar. "I know Humpty Dumpty. I will speak with him."

After the Caterpillar left, Alice wondered if he knew the same Humpty Dumpty she knew. She needn't have worried. The next day, the Caterpillar delivered approved programs to the office.

Alice wrote a press release, announcing the season's programs, the Caterpillar as the new Conductor, and her own appointment as Executive Director. She went over the contracts for the performance halls rented for the season. She found a few unspecified costs that would raise the budgeted rental somewhat but, she decided, not enough to be concerned about. She and Mouse completed applications requesting funds from local governments and mailed them off with appropriate documentation. A bill arrived from the Duchess for the tea party. Alice thought that a bit odd, but she told

Dinah to pay it.

She received telephone calls from several angry Birds. One of them was furious that Alice had contacted her branch bank for a contribution without consulting her first. Another felt left out: "All those Birds, they're just a bunch of biddies who keep re-electing each other and they never tell anybody anything!" When Alice said it had been a pleasure to talk with her, the Bird answered, "How can it be a pleasure? All I've done is scream at you."

Alice agreed, but silently, as she hung up the phone.

On Friday, the Duchess called. She had received an envelope full of material from Alice, including a small supply of the new stationery (with the Duchess' name on the masthead) and envelopes, the press release, copies of the subscription letters, and minutes of the Council meeting.

"Alice dear, it's been a terrible day. I was writing all morning— my memoirs, you know—my secretary is out sick, and I'm getting ready for your party, but I couldn't let the day pass without calling to tell you that I received your packet of materials. Alice dear, what can I tell you? I've been waiting for this for *years*. I am *so* glad you are here. It's a new life."

"It certainly is!" thought Alice.

The day of Alice's "coming out" party arrived. The Duchess had asked her to be half an hour early. Alice left home half an hour before she was expected and arrived ten minutes before she was due, so she waited outside the front door until the appointed moment. Then she reached for the ornate knocker. A servant opened the door. He told Alice to go to the Duchess' library, which she did. There she found the Duchess and the White Rabbit deep in conversation. When she knocked, the Duchess said, "You're early and we're busy. Wait in the garden."

"What a curious way to treat a guest of honor," thought Alice. She found a place in the shade and watched the servants set out trays of glasses. Finally, the sequestered ones appeared and the Duchess began to distribute name tags. "Name tags, indeed," thought Alice. "My word, it's just like a convention!"

Presently, guests began to arrive and soon the garden was filled with familiar and unfamiliar faces. Alice remembered some of them from the Council meeting but all the rest became a blur of

names and faces. She waited for the Caterpillar to arrive, but he never did. The Tweedledees and Tweedledums were there, and the Knave. He introduced Alice to the March Hare who gave her a penetrating look and said, "Now you just take hold, and take action and don't pay any attention to most of them. If you're successful, that's all they want. I'm behind you."

After about an hour, the Duchess took Alice by the hand and led her to the center of the crowd. "Quiet...quiet everyone," the Duchess said, clapping her hands sharply. "It gives me great pleasure to introduce officially to you, and to welcome most warmly, Alice, who has come to us from a great distance. Her credentials are exemplary and we have every expectation that, under her guidance, our Orchestra will rise to the highest pinnacles of success and achievement." She turned to Alice and said, "Alice dear, wouldn't you like to say a few words?"

Alice curtsied to the Duchess and tried to cast a winning smile at the assembled guests. She said how flattered she was by the Duchess' remarks, that she hoped she could live up to them, and that she was looking forward to getting to know and work with all of them. After that, everyone began to leave and, before long, Alice was left alone with the Duchess and the White Rabbit.

It was then that she learned why she had been shut out of their conference. They had news which, they told her somberly, threatened to destroy the Orchestra. It seemed that following the Birds' meeting at Tweedledee's, one of them had gone to see the Gryphon. According to the Gryphon, that Bird had reported all sorts of nasty things which were allegedly said about him by the White Rabbit. (As Alice recalled the meeting, nothing of the kind was said but, as the tape recorder had been turned off, there was no proof.) And the Gryphon, who had independent business dealings with the White Rabbit, said he would never speak to him again. So the Duchess and the White Rabbit had written a letter to the Birds, which the Duchess proceeded at once to read aloud to Alice:

We came to you most willingly,
Responsive to your call.
The meeting went quite swimmingly,
A boon to one and all.

We thought the past was lain aside,
The cobwebs swept away.
We felt suspicions old had died,
No dragons left to slay.

We now remind you of the fact
That we had faith in you.
We did not want to force a pact,
Our trust in you was true.

But one—or more than one—of you
Has told the Gryphon lies.
It was an awful thing to do,
To act as nasty spies.

The Gryphon is quite furious.
He hopes we all will rot.
We find it downright scurrilous,
This whole disgusting plot.

And so, dear Birds, we must insist
The culprit now confess.
The rest of you must not desist
Your innocence to press.

We must demand from each of you
A declaration sound.
In writing or in private view,
As long as all are bound.

If we don't get our way at once,
We two will both resign.
We'll have to leave you in a trunce.
The outcome is all thine.

The Duchess set the letter slowly and gently on the table and turned to look at Alice. Throughout the recitation, Alice could hardly believe her ears. Now the eyes of the Duchess and the White

Rabbit were intent on her.

"Well," said Alice, "I must say that...I mean it *is* extraordinary and completely...I do feel your letter is a brilliant one, certainly, but...of course, you have had time to...I would appreciate thinking about it a bit more?" That seemed acceptable and so, taking a copy of the letter with her, Alice left them, shaking her head and trying to look serious. And it *was* serious, but not for any of the reasons they thought.

"Oh dear," said Alice, once away from the house. "They appear to be the only glue holding this thing together, and if they leave, *I* will be left!" Before she could consider what that would mean, she caught sight of a growing grin emerging in the bushes ahead of her.

Alice didn't even wait for the eyes to appear before she said, "Oh, Cheshire Cat, I am so glad to see you. Something awful has just happened."

"I know," said the Cat, as his body took shape around the grin. "Cheshire Cats know everything."

"What am I to do?" said Alice, fearing she was about to cry.

"Oh, I don't know *that,*" replied the Cat. "I told you we're all mad."

"I think," said Alice, sitting on the grass next to him, "that you're right. I even think you may be right about me, too. Nevertheless, this letter has to be sent, even if it is the silliest letter ever. I suppose," she added, "I could try to convince them to soften it a bit."

"You do what you think best," said the Cat, as he faded away.

"Oh dear," said Alice, "he does have the strangest way of coming and going." But she felt better for having talked with him.

The next day, the Duchess insisted the letter be sent, and everyone waited to see what would happen. Ultimately Magpie (it *had* to have been Magpie) didn't confess but she did resign, and Alice hoped that would be the end of it. But the Duchess and the White Rabbit remained firmly resolved on having declarations of innocence from all the Birds. A few of them did telephone the Duchess and, for the rest, Alice told the Duchess they'd assured her they didn't do it. The Duchess, after some moments' consideration, said that was good enough for her if it was good enough for the White Rabbit. "Thank goodness," Alice said, when the White Rabbit agreed.

Chapter 2

Shortly thereafter, Alice realized that no one had planned a benefit event for the year, so she set about trying to decide what could be done at such a late date. Certainly getting a guest of honor was out of the question but she decided something could be planned around the major performance of the season. "Dinner before the concert could be the very thing," she thought, "to celebrate our twentieth anniversary."

She asked Dinah to arrange a meeting of the Birds, a sort of "rally 'round" meeting, hoping to stimulate them and begin to get them organized. She gave what she hoped was an inspiring speech, telling them how vital they were to everything the Orchestra did. The Birds seemed receptive, so Alice explained the necessity of making a benefit evening to help cover the projected deficit, and she outlined her plan for the dinner. They appeared to like the idea until Alice told them she hadn't planned any dancing.

"No dancing?" said the Crow.

"No dancing?" shrieked the Lory.

"No dancing?" chirped the Sparrow from the corner.

"*No* dancing," said Alice. "There won't be time."

Alice remembered the elegant luncheon Tweedledee's wife had given for the ill-fated Birds' meeting a few weeks earlier, so she

asked her to be Chairbird for the Banquet Committee. "I'll do the work, Alice," Mrs. Tweedledee said, "but I won't be Chairbird, because I don't want my name on anything I know is going to fail." So Alice's 20th anniversary celebration was born.

Before she knew it, it was time for the first concert of the season. Everything had been done: press releases; radio spots; fliers and posters; Alice and the Caterpillar had done some radio interviews; and the program was printed. There was a good crowd. Before the curtain went up, Alice made a little speech to welcome everyone, particularly the Walrus, who was a world-famous artist and the Orchestra's Honorary Chairman. (That was the only reason for the speech because Alice didn't feel that concerts were the place for speeches. Besides, speeches made her nervous.)

At intermission, Mouse came running up. "The Mad Hatter is here! The Mad Hatter is here! You'll have to meet him." Alice had, quite truthfully, forgotten all about the Mad Hatter, but now she remembered the Duchess' warning.

"Oh dear," thought Alice, "now I shall find out how to meet him and still have nothing to do with him." Mouse was pulling her through the crowd and, shortly, she and the Hatter were face to face. Actually, they were *hat* to face because the Mad Hatter was the smallest person Alice had ever seen. (He made her feel her normal size for the first time since she'd arrived.)

"How do you do?" said Alice, bending down and hoping it was proper for her to speak first.

"So you're Alice," said the Hatter. "I've heard about you." His eyes narrowed to slits as he scrutinized her face. Then he turned abruptly and walked away, followed by the Mock Turtle.

"That's his keeper," whispered Mouse to a stunned Alice. "He's been the Hatter's companion for years."

When the concert was over, the audience cheered loudly and there were many curtain calls. After that, Alice had planned a little reception and had insisted that some of the Birds organize it. They hadn't wanted to. They said no one would come, so Alice was delighted when so many did. There was such a crowd, in fact, that they ran out of refreshments long before it was polite to do so.

Alice was consistently amazed by incidents she learned had taken place in the past. One wealthy woman had made a significant contribution. It was equal to that required of Board members, so her name was added to the Board. No one asked her if she wanted to be on the Board, however, and, as she did not, she refused to give any further support. Alice also discovered that there had been one other Executive Director a few years before her. He had demanded a high salary, an automobile and an expense account. The total cost of all that came to nearly three times what Alice was being paid and, she was told, he hadn't raised a cent. "No wonder they've had financial difficulties," thought Alice.

Attending to that side of things, Alice managed to convince Tweedledum that three-page letters, single-spaced with half-inch margins, were not effective fund-raising tools. She began to develop some promotional materials which could be submitted to prospective contributors. And, at the next Board meeting, Alice presented her revised budget, one which showed a projected deficit equal to the surplus estimated in the White Rabbit's budget. But when she presented a fund-raising plan, in which all members of the Board were expected to participate, the Duchess changed the subject.

A few days later, the Council held another meeting. One of the principal items on the agenda was final approval of the proposed Youth Concerts Program. It was not approved. On the contrary, the Council decided they didn't like it at all and that the program had to be completely revised. They also rejected an idea that Alice and the Caterpillar had for a special concert. Alice thought she could raise the money for it, and both of them thought it would create the same excitement similar programs had generated elsewhere. It was principally vetoed by Humpty Dumpty who said, "That's the stupidest idea I ever heard. Nobody's interested in that kind of music anymore."

"What is so peculiar about this place," Alice told the Caterpillar later, "is that they don't do anything anybody else is doing, anywhere. It's like everything's backward."

The meeting just added to Alice's frustration with having to be responsible, and responsive, to both the Council and the Board.

"Getting something done around here isn't going to be easy," she said one night to the Cheshire Cat.

"Who do they think they are?" he replied. Alice knew the question was rhetorical but she continued. "I don't know who they think *they* are," she said, "I want to know who they think *I* am!"

"Oh, they don't care who *you* are," said the Cat, as he faded away.

Alice remembered the advice of the March Hare and wondered if she *should* "take hold and take action." If she were successful, *was* that all they cared about? Alice wasn't sure. The only thing she was sure of was that if *she* didn't do something, nothing would be done.

In the days that followed, Alice continued to prepare for her 20th anniversary dinner party. She designed a simple invitation, and printed thousands. A number of reluctant Birds were persuaded to come in to address envelopes, using every list Alice could beg, borrow, or steal. After endless days of addressing, collating, stuffing, sealing and stamping envelopes, the invitations were ready to mail, approximately six weeks before the date of the dinner.

Other than that flurry of activity, things had been relatively quiet. Alice spent several evenings evaluating the guidelines of various foundations to determine to which she might apply, and for what. She and Tweedledum met with a number of corporate givers, and obtained one new grant and one renewal. Alice was pleased.

Mouse made some appointments for Alice and herself to visit a few key Board people, including one lady who was, now, the Orchestra's largest individual contributor. And Mouse took Alice to meet the famed Walrus.

They arrived at his home at the appointed hour and he, himself, answered the door. Lumbering, he led them into the living room and indicated that Alice was to sit next to him. Mouse said how nice he was to make time to see them and how well he was looking and then Walrus began to speak.

In his deep, heavily accented voice, he spoke of many things, of tours and fame, and cold hotels, appearances for kings. Alice

sat raptly, barely breathing. After an hour, he smiled at her and stood up. He saw them to the door and, as they parted, he bowed and kissed Alice's hand.

One morning, about a week later, Alice answered the telephone in Dinah's absence. The voice said, slowly and deliberately, "I'd like to speak with Alice."

"Speaking," she said.

"This is a secret admirer."

"Oh dear," said Alice, and the voice chuckled.

"Don't be embarrassed. I just want to say how pleasant our little visit was, and to ask how you are." He rolled his r's and "little" came out "leetle."

"Oh, I'm quite well, thank you," said Alice, as brightly as she could, and she started to regale him with some of her most recent activities on behalf of the Orchestra.

"Wait, wait..." the Walrus interrupted. "I don't mean that. I want to know how *you* are. Are you happy? Do you have friends? Is there anything I can do for you?"

Alice suddenly felt very foolish. "Oh, thank you," she stammered. "Yes, I am happy here. Thank you so much for asking."

"And there's nothing I can do?"

"No, no, but I do thank you."

"Then I will see you at your dinner. I am looking forward to it." And he hung up.

Soon, every moment was filled with preparing for, or worrying about, the dinner party. The mails were not flooded with reply cards and checks, and Alice began to fear that the nay-sayers were right. Some members of the Board even suggested the event would lose money, despite Alice's figures and budget explanations.

"Oh, for heaven's sakes, I wouldn't have planned the whole thing if it weren't going to make *some* money," Alice said. And, in her opinion, any amount was better than none at all.

Alice planned a souvenir book and sold pages to add some income that way. The March Hare donated the printing, and non-advertisement pages were filled with congratulatory statements. The first page was a letter from the Duchess, written for the occasion.

As it turned out, Tweedledee's wife didn't do the work, as she said she would, but she made seemingly endless suggestions which sent Alice running hither and yon, purchasing and organizing things at her direction.

The list of reservations grew slowly but daily and, finally, 250 were expected in attendance. Alice felt it was a triumph. Of course, she had no way of knowing that the worst dilemma lay ahead: seating. Everyone wanted to sit with everyone else, and everyone wanted to sit with a *some*body. "Oh dear," thought Alice, "the only solution is one gigantic table in the middle of Looking Glass Park!"

The big day arrived. Some of the Birds were due early to set out the candles, table decorations and souvenir books. None appeared, but Alice, with help from Mouse and Dinah, got everything done. Other Birds came late to check people in and hand out table assignments but, eventually, everyone was in, and seated, and dinner was served. Alice couldn't eat a morsel, so worried was she about anything and everything, but she was told that the food was quite good. And the speeches were short, except for the Duchess who insisted upon reading the letter she'd written for the souvenir book, in its entirety, plus other remarks. But nicest of all, for Alice, was the presence and warm greeting of the Walrus.

The concert that evening was a total success and the Caterpillar got nine curtain calls. Afterwards, major contributors celebrated at a champagne reception which Alice had organized without help—or discouraging words—from the Birds. All in all, Alice felt, it was a singular success, and the dinner made enough to pay for the food, the rental of the hall, the Orchestra fees, *and* there was a little over one thousand to spare!

"Not bad," noted Alice, the next time she saw the Cheshire Cat, "not bad at all."

"I knew you could do it," said the Cat.

Alice had begun to make appointments to meet the inactive Board members. Her most successful interview began in the worst way.

"Good morning," said Alice, her hand outstretched.

"Sit down," the White Knight said, remaining seated himself. "What do you want?"

"Well," said Alice, "we hadn't met and I thought it would be nice if we got acquainted."

"It might be nice but I haven't time," he answered.

"I'd like to bring you up to date on what's been happening," Alice ventured.

"I don't care what's been happening," he responded. "I only joined the Board because the White Rabbit insisted and I told him at the time I wouldn't come to meetings. I send my money every year and he has the use of my name. By the way," he continued, leaning forward, "how is the money situation?"

When Alice had explained, he asked what the Board was doing about it. Alice tactfully told him his colleagues were not living up to her, or perhaps his, expectations.

"Would it help," he asked, "if I were to give you extra money this year to help you influence the others to do the same? That's the way it ought to be done, you know."

"I do! I know! Yes, sir! Oh my! I'm sure it would! Thank you!" The words tumbled out of Alice's mouth and seemed to spill all over the desk between them.

"I'll tell you what else I'll do," said the White Knight. "My wife, Mary Ann, might be interested in serving in my place. The children are in school now and she might enjoy that. Then, you'd have my name, my money, *and* a worker. Do you want me to ask her?"

"Oh, please do," said Alice, "and thank you again!"

Challenged, Alice returned to the Board and insisted they had to repay the bank loan out of their own resources. She emphasized that, until the loan was repaid, all fund-raising efforts would be severely hampered, if not made impossible. Tweedledee rallied himself and, armed with the White Knight's pledge, he launched a one-man campaign to call fellow Board members and other friends to raise the required money.

Alice did what she could, as well, and convinced one local philanthropist, who was fond of the Duchess, to make a contribution. He agreed to match one dollar for every three raised in the cause.

At the same time, Alice was constantly reviewing the Orchestra's cash flow. The dinner had helped, of course, but it was still not going to be easy to finish the year with the income equaling the expenses, which was her goal. And suggestions from the Board never seemed to be in the nature of how to raise income but always where to cut expenses. First, they asked Alice to take the bookkeeping and accounts away from the accounting firm and have

them done in the office. It would mean considerably more work for her but a sizable savings, as well. Then, they asked her to consider letting both Mouse and Dinah go, replacing them with someone better qualified than either, especially someone who could keep the books, and handle the work of both.

Alice had grown very fond of Mouse and it was difficult to think of firing her. But of one thing Alice was certain: she would not part with Dinah. Dinah seemed to know as much about who everybody was and where everything was as Mouse. What's more, her typing and dictation were improving, and Alice knew she was interested in becoming a bookkeeper.

So Alice told Mouse that the Board had demanded a staff cut and she would have to go. Alice bought her a very expensive farewell gift, feeling it was the least she deserved, after so many years.

Alice decided she would need help from the Birds to make up for the loss of Mouse, so she steeled herself for the onslaught promised by the Dodo, their new President. Some came to help; some didn't. Those who didn't always waited until the morning they were scheduled to work to say they had a cold or had stubbed their toe or had cousins unexpectedly drop in. Those who did come weren't generally very helpful. When Alice explained what needed to be done and the best way to do it, most of them refused to do it that way. Often they would come in for thirty minutes and gossip over coffee for twenty. Alice didn't take the time to join them, as Mouse always had. She did try, however, to greet them on arrival, thank them on departure, and she wrote each a thank-you note for every visit. But it wasn't enough. The Birds became less and less willing to come to the office, and many complained to the Duchess that they didn't like Alice. Finally, they stopped coming altogether.

The work situation was saved by Bill. Alice was never sure how old Bill—who looked rather like a lizard—was, but he was old enough to live on government benefits and he devoted his time to piano lessons (beginning variety), Spanish (adult education), and charity work. Bill had volunteered for a local radio station but they gave him "too much responsibility" so, one day, he appeared at Alice's door. He returned any time Alice called him, as often and for as long as needed. He sat in Mouse's old office and stuffed envelopes, zip-coded envelopes, counted envelopes, meter-stamped envelopes and labeled envelopes. He became indispensible and seemed perfectly content.

One day, the Dodo rang to report that the Mad Hatter had come to her with a project he wanted the Birds to do.

Alice knew nothing about it and decided the time had come to have a little talk with the Hatter. She wrote, saying that if he had any ideas or projects in mind, they should meet and talk them over. Alice said she would be delighted to see him. A few weeks went by before the Hatter called for an appointment. He came to the office accompanied, as usual, by the Mock Turtle. The Turtle sat with Dinah. The Hatter closed the door to Alice's office behind him.

Alice viewed him warily. He was obviously suspicious, too. But, as their conversation went on, Alice felt herself warming to the old dear, and to his idea.

What the Hatter had in mind was a series of lectures for children in the schools. Members of the Orchestra would be selected to demonstrate musically; members of the Birds would give the lectures and act as mistress of ceremonies during the question-and-answer period. Although such an idea was not really within the parameters of the Orchestra's by-laws, it would provide extra income to the musicians and, with an administrative fee written into the grant proposal, would provide additional income to operations.

"I know," ventured the Hatter, "that you aren't getting on all that well with the Birds. Think how pleased they will be to do this. They need to be involved, as they were when I began. There wouldn't have been an Orchestra without them, you know."

"Oh, I do know," said Alice, "but I must disagree about their involvement. I think we need a professional, someone who could do all of the lectures. That way, we can maintain the quality of them. I agree we should present different musicians, different instruments, but I will insist on one lecturer."

"You may be right," said the Hatter, "but let's leave that until we have money. Do you think you can get it?"

"I can only try," promised Alice. "But first, you know, I have to have the approval of the Council."

"Of course, of course," agreed the Hatter. "I'm sure they'll be supportive. I'll speak to some of them myself." The first testy air had dissipated.

"How do you think you can handle me?" asked the Hatter before he stood to leave. "The White Rabbit can, but he's been the only one. How do you think you'll do?"

"Do you really need 'handling'?" asked Alice, and the Hatter

laughed. They seemed to part friends.

Shortly after, the White Rabbit accepted an important position with a firm some distance away, and he resigned as Chairman. Until elections the next fall, Tweedledum, who had been Vice-Chairman, assumed the post. Alice would miss the White Rabbit, though he had never had much time for her, but she looked forward to working with Tweedledum. He seemed a kindly and devoted old gentleman, and had even given her a lovely un-birthday present.

Chapter 3

It was nearing time for the annual competition to select the next year's soloists. Alice needed to find out what the requirements were so she could make up an application form and send out announcements. As she read the files, she was puzzled to discover that everything about the competition had changed from year to year, for the past five years: age limits; what instruments were eligible; and what repertoire was required. The last part didn't worry Alice; she'd done that before and decided to use the same guidelines. But she did need to know the other things, so she called a meeting of the Council to ask them what they wanted her to do. After a great deal of bickering among themselves, they finally came to an agreement on the questions Alice asked. But then, without much discussion at all, they decided that the competition should be postponed until the following fall.

"No vun vill be ready on such short notice," said the Dormouse in her piping little voice. So it was decided, and the meeting was adjourned. Alice was beside herself, and the Caterpillar was furious when she told him.

"Oh dear," said Alice, "how can we ever plan a season without knowing who the soloists will be? How can you decide what to perform? And, as for their not being ready, the repertoire is perfectly standard. If they're not ready now, they won't be in the fall, either.

Besides, *no* one…" and she stamped her foot on the ground so hard that it stung…"waits until the season starts to begin to plan it. That's unheard of!"

So the next day, she telephoned the Duchess and said, "It simply won't do." Alice convinced the Duchess that the competition should not be postponed and set about to convince the others. They weren't convinced and they didn't like it, but Alice insisted. Then she got down to the business of arranging it and, in no time, all the information was in the mail to the press and to the many applicants who had already requested it.

Alice had set the dates and locations but she had yet to select a jury. She went over the list of previous year's members, added those names suggested by the Caterpillar, and wrote to each. One of the first to reply asked her if the Mad Hatter was to be involved. "The last time I served on this jury, he ignored everything we decided. I'm not going to put up with that again!" he said.

The Hatter *had* asked Alice if he could attend and Alice said he could but only if he promised not to take any part in the judging—not even to say a word. He had agreed. So Alice assured her juror that the Hatter would only be an observer. (Alice hadn't wanted the Hatter there at all, but he had asked so nicely, she couldn't imagine he would do any harm, and the Caterpillar agreed.)

The Hatter was true to his word and the preliminary auditions went very well. By the end of the second round, the jury had selected seven finalists. The finals, however, were a different matter. Humpty Dumpty joined them at the last minute and, when everyone met to select the winners, he declared, "It was a total waste. Not a single talent worth giving a second thought to. I couldn't hold up my head in this town if we took any of them." No one, it seemed, dared to contradict him. The Duchess, who was normally quite strong in her opinions, remained silent and the Caterpillar puffed on his pipe without a word.

Later, the Duchess spoke to Alice. "You know, Alice dear, everyone is quite upset with you and I can't say that I blame them. You really had no right to take things into your own hands. It was too fast and the repertoire was all wrong—not right for us at all. I can't imagine where you got it. No one with any real talent would enter a competition like the one you have just been responsible for." When Alice tried to remind her that no one had any complaints until Humpty Dumpty came on the scene, the Duchess said, "They

were only the jury. It's the Council you have to answer to."

"It was much more pleasant at home," thought poor Alice, "when one wasn't always being lectured by deposed royalty. I almost wish I hadn't gone down the rabbit hole—and yet—it's curious, this kind of life. When I used to read fairy-tales, I thought that sort of thing never happened, and now here I am in the middle of one. Someone ought to write a book about this, they really should!"

"What is it," asked Alice one day when she met Mouse for lunch, "that makes everyone dislike the Hatter so?"

"He's mad," answered Mouse.

"Well, I can't see that he's any more mad than any of the others. A little more eccentric, perhaps, but that's all."

"Oh no," said Mouse, "he's mad as a hatter!"

"But what did he *do*?" asked Alice.

"Oh, so many things," said Mouse. "So many, I hardly know where to begin."

"Begin at the beginning, then."

"Well, when the Hatter was little—littler than he is now—he was a child prodigy. He started the violin when he was three and a half and began giving concerts when he was six. When he was ten, he was signed by the great impresario, Sal Herrick, who booked him in concerts all over the world. He was hailed as the greatest violinist the world had ever known. But, when he was sixteen, he told his family he would never play again. And he never did, at least not in public.

"Nobody really knows what he did after that but, twenty years ago, he met the Walrus and got his support for the creation of the Orchestra. He was crazy then but he had such a forceful personality, he got the job done. The real problems began when the Board decided to hire a professional director. The Hatter knew he couldn't do the job himself but he still resented anyone else doing it.

"He remained involved, and people thought of him as the patriarch of the Orchestra, but his behavior got more and more erratic. One year, they decided to honor him with a Gala Benefit. But two weeks before, he suddenly announced he wouldn't attend and we had to cancel everything. Another time, the night before the Gala, he got into the office and changed all the seating assignments. No one knew, of course, until they got to the ballroom. You can't imagine what a mess it was!

"One year," Mouse continued, remembering more, "he didn't like the concertmaster so, before every concert, he'd go into the dressing room and steal his bridge. The concertmaster finally fled and that was when the Duchess, who was Chairman then, convinced the Board to banish the Hatter. He left town and only just came back. So that's why the Duchess told you not to have anything to do with him."

"Well," said Alice, "that's not going to be easy because people like the White Rabbit and Tweedledum, who don't know any of this, like the Hatter."

"I know," said Mouse. "He can be absolutely charming when he wants to and he's won them over. He seems to have won you over, too. And his old friends in the Birds are still around. He has support."

"Oh dear," said Alice, wondering if she would be able to "handle" him, after all.

The monthly meetings of the Council had only been a subcommittee of the seventy members officially listed, so a full Council meeting was scheduled to conclude the season. Dinah mailed announcements and asked everyone to call to confirm their attendance so Alice could plan enough refreshments which, she was told, were mandatory at such meetings. After a week and a half, four members had responded and two of those said they couldn't come. Alice consulted with the Duchess and Humpty Dumpty and they agreed the meeting should be canceled.

At the same time, however, Humpty Dumpty asked the Dormouse to call a meeting of the subcommittee members for the same evening. So, while Dinah was telephoning to cancel the full Council meeting, they thought she was canceling the subcommittee meeting which, at that point, Alice didn't even know about because, as the Dormouse told her, "I know how busy you are, and I didn't vant to boder you." Alice called the Duchess, who called Humpty Dumpty, who said, "Of course, we don't need a meeting."

"How confusing," Alice said to the Duchess. "If he says we don't need one, what did he call one for?"

So Dinah began calling the members to cancel that meeting, including some who didn't know about the second meeting anyway, because the Dormouse couldn't remember exactly who was on the subcommittee in the first place, or whom she had already invited

in the second place.

Late that day, the telephone rang and it was Humpty Dumpty. "Call the Dormouse, and tell her I didn't cancel the meeting—*you* did," he demanded.

"But *you* did," said Alice

"When?" replied Humpty Dumpty.

"Today, when you spoke with the Duchess," answered Alice.

"I did *not*, and I'm fed up with you and this whole damned organization. It's going to hell and I don't want to have any more to do with it. I resign!" he shouted, and slammed down the phone.

The next day, the Duchess spoke with Humpty Dumpty and learned that the Dormouse had seen him at a concert the previous week. She had begun to complain about Alice, principally over the matter of the competition, so Humpty Dumpty suggested they meet with the Duchess to discuss it. The Dormouse got confused and thought he meant the entire subcommittee and so, when Humpty Dumpty spoke to Alice, he was referring to the first meeting which Alice had canceled, not the last.

Alice felt as confused as the Dormouse and had no idea who was supposed to do what. She had always thought that Executive Directors directed things, but that certainly didn't seem to be the case here. The Duchess said, "Alice dear, don't worry. We'll weather this storm together," and she called a meeting of the officers to discuss what Alice should do. When they had gathered, Alice addressed them.

"Gentlemen and madam," said Alice, "you must see that this is an impossible situation. The Board is making one set of decisions and I am expected to follow those instructions. The Council is making another set, which they also expect me to follow, which I then have to bring to you for approval or disapproval—once they manage to agree on anything, that is—and I feel like a croquet ball on a freshly mowed green. Please tell me, to whom am I responsible?"

The officers asssured her she must answer to them and told her to "keep the show on the road," to do as she felt best. So Alice continued to plan the next season.

For the most part, Alice was pleased with the way things were going. She had managed to bring in some more money and Tweedledee was making progress in his campaign to repay the bank loan by year's end. She and the Caterpillar had some exciting ideas for special concerts to be given the next year. She had already secured funding for one and prospects for the other looked good. And through the efforts of both Alice and Tweedledum, there was a foundation interested in funding the Hatter's project. The Duchess and the Board knew about the concert plans; Alice left it to Tweedledum to bring up the Hatter's project.

It was about this time that Alice received a call from the Dodo. "Alice dear," she said, "the Dormouse just telephoned, and she has asked me to write a letter to the Duchess and to Tweedledum, requesting that your contract not be renewed. I just want you to know that I have no intention of doing any such thing."

"Well," said Alice, after she hung up, "that's an amusing thought, since I have no contract to be renewed or *un*renewed."

When Alice heard that funding for the Hatter's project had been approved, the Hatter was away. She sent a wire with the good news and began to interview people to be the lecturer. She wanted someone young and energetic, someone the children would like. She thought the Larkspur would do an excellent job but waited to hire her officially until the Hatter's return.

"That is *not* what I wanted," stated the Hatter when Alice proposed the Larkspur.

"You do recall," said Alice, "that I made it clear that was the only way I would do this project. I recognize that it was your idea but it's up to me to run it the best way I can. And using the Larkspur is, in my opinion, the best way. She's utterly charming. You'll like her, you'll see."

"Well," said the Hatter, grudgingly, "I certainly hope so."

In the end, the Hatter didn't really care for the Larkspur, but he reluctantly agreed to let her try. He said he would attend her lectures to see how she did. So would Alice.

In planning for the coming year, Alice had emphasized to the Board the necessity of having a major benefit evening. She could

see no other way to raise the money that would be needed. The Duchess was enthusiastic. She loved parties and had organized many such affairs for other organizations, so she was sure she was an authority on the subject.

"We must, however, bear in mind," she told the Board, "that these affairs are only successful when planned well in advance. The best groups begin the morning after one affair to plan the next, and nothing is done without a phalanx of society Birds working from morning to night. Our own Birds, devoted as they are, I am sorry to say, don't have any idea how to organize such an evening. I don't have to remind you that we are in Wonderland and anything ordinary simply will not do."

It was a speech Alice was to hear many times, but one with which she could only partly agree. Their Orchestra Association was small, and did not have the reputation of the major ones the Duchess had in mind. Even with help, Alice doubted they were capable of the kind of Wonderland extravaganza the Duchess envisioned. At that time, though, it was not appropriate for Alice to contradict the Duchess, so Tweedledee was appointed to secure a Chairbird to head the required "phalanx." Tweedledee, Tweedledum and the Duchess appointed themselves as the committee to choose a guest of honor. Alice was elected a committee of one to find a hotel, a room, and to pick a date. She decided it should be early in the year so that the proceeds would keep everything else going; the fall and winter could then be spent in the other fund-raising efforts needed to finish the season.

Although it was late, Alice was able to reserve one of the smaller rooms—maximum seating eight hundred—at a major hotel for an early date. In the meantime, the Guest of Honor Committee learned that their first choice was unwilling to be honored. Tweedledum and Tweedledee discussed the situation and decided they should honor someone who had been with the Orchestra for many years, who was devoted to it and who, by now, deserved such a special accolade. Their choice was none other than the Duchess.

Just before the end of the fiscal year, Alice and Tweedledee had raised the money necessary to repay the bank loan and end the year "in the black." Alice was ecstatic and Tweedledee was, in his quiet way, no less so. It was not, however, possible to repay the bank immediately due to simple cash flow. Until subscription renewals for the next year began to come in, Alice had no money for salaries

or the tax payment due. It would be necessary to "borrow" from the bank repayment money. She consulted with the Knave, who served as Treasurer, and with Tweedledum. They agreed it was the only thing to do.

Tweedledee was furious. "You lied to me," he shouted at Alice. "You said the loan was repaid. I've been telling everyone the loan is paid. Now I find you're spending the money I raised on something else. How could you be so deceitful?" Alice tried to explain, but there was no reasoning with him, and he stopped speaking to Alice.

"How perfectly childish," thought Alice, but she was disappointed because she very much liked Tweedledee, and it made her sad that the joy of their accomplishment could so suddenly turn sour. But there was another, even more serious problem. Tweedledee, who was to have secured a Chairbird for the benefit Gala, now refused to do anything until the loan money had been received by the bank. That could not be done until the subscriptions began to come in, and *that* wouldn't happen until the brochures soliciting them were written, printed and mailed.

Alice had been working on the brochure for many weeks. She wanted it, above all, to reflect how busy and successful the Orchestra had become, so she used the brochure to announce everything: the regular concert series, the two special concerts, the activities planned by the Birds, and the Gala in honor of the Duchess. She rushed the printing, and the Birds and Bill were rallied to handle the addressing and zip-coding. One day in mid-summer, Alice and Dinah delivered over eight thousand brochures to the main post office.

Within a few days, the checks started to come in and, at the end of the week, Alice made out a check to the bank, marked "payment in full." She made a copy of the check and sent it to Tweedledee with a congratulatory note. Only then did he approach the society Bird everyone wanted to head the Gala committee, but she turned him down.

By then, the Gala was only three months off and the Duchess, discovering that absolutely nothing had been done about assembling her phalanx of Birds, called an emergency meeting. She read off a list of Birds who could either act as Chairbird or serve on the committee. Tweedledum was called upon to contact each one, in order of desirability.

The first said no. The second, the Tiger-lily, who was a pillar of local society and lioness of gala affairs, agreed to serve if the Red Queen, who was on the Orchestra Board, would agree to co-chair. The Red Queen approved the arrangement. That same week, Mrs. Looking Glass, of the park of the same name, agreed to be Honorary Chairbird. Alice heaved a sigh of relief, thinking that her problems were finally behind her.

In the interim, of course, Alice had been preparing for the Gala as best she could on her own. She asked an artist to make a simple line drawing of the Duchess to be used on the cover of the invitation. This was approved by the Duchess who said, "It's really a bit flattering, Alice dear, but that's all right. Go ahead and use it as it is."

Alice chose the invitation paper stock with the help of the March Hare, who once again had volunteered to donate the printing. Then she ordered the envelopes to be delivered early so that the Birds, barely recovered from addressing the brochures, would have time to hand-address them. The day Alice learned that Mrs. Looking Glass would be Honorary Chairbird, she was able to send the final copy to the typesetter. Two days later, the art work needed by the printer was delivered to the March Hare.

Alice had also written to more than one hundred friends and colleagues of the Duchess, asking them to write letters of tribute which Alice would have bound in a special embossed leather book as a surprise presentation for the Duchess at the Gala. She also solicited citations and plaques from the City, County, State and anyone else she could think of, including the President. Finally, at the request of Tweedledum, she wrote to innumerable people, asking them to become patrons of the evening. As such, they would be invited to an afternoon champagne party hosted by Tweedledum and his wife.

Despite this flurry of extra activity, the normal pre-season Orchestra business had to go on. Ads had to be sold for the season's program books, which had to be designed and printed; radio and television stations had to be called to arrange for interviews to promote the season; fliers and posters had to be designed and printed for the opening concert; the Hatter's lectures had to be scheduled and the musicians chosen; and general fund-raising could not be completely forgotten. Somehow, with overtime help from Dinah, everything managed to get done.

The Larkspur obviously enjoyed giving her lectures and her winning manner sparked enthusiastic response from her audiences. Alice felt that was more important than her occasional lapses in strictly accurate musical references. The Hatter did not share Alice's opinion about the Larkspur, but Alice retained her and hoped for the best. Preparations for the Gala had to be Alice's first priority.

Alice had not been working on the Gala entirely alone. She was aided by the White Queen, a dear friend of Tweedledum's, who had recently become devoted to the Duchess, and who wanted to help in any way she could with the preparations "for the darling Duchess," as she called her. Although Alice had been warned by the Duchess to do nothing without consulting the Chairbird of the evening, Alice worked with the White Queen on what had to be done because, prior to recruiting Chairbirds or forming committees, there was no one else—except the Duchess herself. And, by the time there *were* Chairbirds and committees, the Gala was only seven weeks away.

The White Queen seemed to understand the need for balancing protocol against the urgencies of time, and Alice relied on her a great deal. Indeed, so impressed was she by the White Queen's dedication and ideas, Alice suggested her membership on the Board. That pleased Tweedledum and, at the first meeting of the year, the White Queen was duly elected, along with Mary Ann who replaced the White Knight on the Board. Tweedledum was asked to continue as Chairman.

As soon as the Tiger-lily and the Red Queen agreed to be co-Chairbirds, a meeting was called to begin to get everything organized; however, because of Tiger-lily's other commitments, it was a week before anything could be scheduled. On the day that the Chairbirds, the White Queen, the Dodo, Tweedledum and his wife, and Alice could meet, the invitations were delivered to Alice's office from the March Hare's printer. They were returned immediately. They were printed in one color, not two, and the stock was not what Alice had selected. The former error was correctable; the latter was not. Alice saved a few and painted in the second color by hand so she could show everyone at the meeting what they were supposed to look like.

The invitation did not meet with approval. The Red Queen said, "It's too small."

Tiger-lily said, "The paper's too heavy."

"The paper's cheap!" added the Red Queen.

Tweedledum's wife said, "It's disgusting." She drew her lips to a brittle line.

"Who do you think you are?" Tiger-lily asked scornfully of Alice, who sat numbly at her desk.

"They must be redone!" demanded the Red Queen, and Tiger-lily said, "I won't have my name on anything that's not 'black tie'." (The Board had voted against black tie; at least *that* wasn't Alice's doing.)

"And speaking of names," shrieked the Red Queen, "what is Alice's name doing on the back of the invitation?!"

When everyone but the White Queen and the Dodo had left, the White Queen began to cry. "I don't even talk to people I don't like that way," she sniffled, looking sadly at the dejected Alice. They tried to decide what to do. They still liked the invitation, as did the Duchess when it was shown to her, and all three felt that the most important thing was to get them in the mail as soon as possible.

But the next day, Tweedledum called on the Duchess to say that, if the invitations were not redone, he would resign. There was a midnight consultation among Alice, the Duchess and the White Queen, and it was decided to reprint. So Alice and the White Queen went back to the March Hare, who couldn't have been more bored with the whole thing, but who promised to have the job completed within a week.

They chose new paper, the most expensive available. Because it was a slightly different shade from the ivory of the first invitation, the pre-addressed envelopes, the return envelopes and reply cards could not be used. So, to accommodate the Red Queen, they decided to enlarge the invitation.

Two days later, so the re-addressing could begin, the envelopes were delivered. They were not of the stock chosen and, further, a printing error rendered them useless. Alice telephoned the March Hare who telephoned the printer who said the stock they selected was not available so the supplier sent the closest thing to it. Alice and the White Queen rushed over to select another. It, too, was unavailable, so what was available was used.

"Oh dear," said Alice, when she saw the the second invitation was exactly the same color as the first. That meant the original envelopes already addressed, could have been used, except for the

fact that the second invitation was a half-inch larger than the first and would not, therefore, fit in the old envelope. In the day and night which followed, Dinah, Alice, the White Queen, the Dodo and friends addressed the five thousand new envelopes, collated and stuffed the invitations, stamped them, and put them in the mail.

Along with the problems of the invitation, another difficult situation was developing. Whereas Tweedledee seemed to have completely forgiven Alice in the matter of the bank loan, Alice was becoming increasingly estranged from Tweedledum. Nothing Alice did seemed to suit him and they began to disagree on everything. He started to criticize her management of the Orchestra's finances and wanted a lawyer or a banker, in addition to the accounting firm which already oversaw Alice's work, to handle everything. He was also becoming extremely forgetful, which complicated their general communication considerably.

The day of the Tweedledums' party for the patrons of the Gala was near. Alice had been taking RSVP's at the office and helping Tweedledum's wife as much as she could, although their relationship was decidedly strained. When the day arrived, Alice went early to be of whatever assistance she could. The garden was filled with tables under colorful umbrellas, and bedecked with a multitude of flowers. In the center of the serving table was an exquisite cake with the likeness of the Duchess taken from Alice's invitation and executed in mocha frosting. Everything was in perfect readiness.

Guests began to arrive, including a few Board members Alice had not met before, despite the whole year she'd been in Wonderland. She greeted everyone as they came into the garden, and chatted with those she knew better. But her heart skipped a beat when she saw the Mock Turtle come through the gate with the Mad Hatter. They were immediately welcomed by the Tweedledums, who escorted them through the crowd. As they approached the Duchess, Alice held her breath. They had never discussed the Hatter or his project although, when the money had been secured and the Council approved it, Alice assumed the Duchess had been told. She was too far away to hear the conversation but she watched incredulously as the Hatter kissed the Duchess' hand and the two began to engage in what appeared to be perfectly amiable conversation.

"Curiouser and curiouser," thought Alice. "Tweedledum must have made peace between them."

It was a lovely party and everyone seemed to have a splendid time. Alice told Tweedledum so when she left but, alas for Alice, he must have forgotten. In the following days, he ceased speaking to her altogether and would only leave little notes for her with Dinah. The White Queen told Alice he was angry with her for not complimenting him on his party.

With the Gala evening looming ever closer, the Duchess' fear, bordering on panic, was that the event in her honor was going to be a disaster. She stopped referring to herself as the "honoree" and took, instead, the title "victim." All of Alice's efforts to assuage her doubts only served to worry her more. "After all," the Duchess said to the White Queen, "what does Alice know about these affairs? Her seeming calm can only result from her inability to assess accurately the potential for disaster." And, of course, no one could tell the Duchess about the wonderful surprises being prepared for her. So the Duchess summoned Alice to her home for a talk.

"Alice dear," the Duchess began, "I love you and you are like a daughter to me. You must listen to me as a daughter would to advice from her mother. You simply cannot go on as you have. This is a volunteer organization and the Birds have complained to me. They find you unsympathetic. You don't appreciate their efforts. They need stroking and praise for their hard work. All volunteers do. Tweedledum does. I do. And in the matter of the Gala, you have blatantly ignored all my advice on how these things are done. I've told you countless times to consult with your committee on every detail. Now the Red Queen is very upset with you. She says you are totally uncooperative and will not give her the information she asks for. She said one day you told her there were four hundred reservations; the next day, you said there were one hundred and seventy. How can your records be so sloppy? Why have you not sent daily updates to me and to your Chairbirds?"

The lesson went on and on but the knots in Alice's stomach did not lessen. She was, she kept thinking, doing the very best she could and for the life of her, could see only that her work was the doing of the Gala, not the *un*doing. Didn't they remember she hadn't *had* a committee of Chairbirds to consult with until just two weeks ago? Where would they all be if she'd waited until then

to do anything? And how could the Red Queen have misunderstood her to say that four hundred reservations had been received when, in truth, Alice told her that she estimated a *total* attendance of that many by the night of the Gala.

"Alice dear," the Duchess continued, "I know that I have not wasted this morning with you." And, indeed, their meeting had taken the entire morning. "I know you feel better, too." Alice did not feel well at all, but there was much more work to be done and she still believed she could see the Gala through to a successful conclusion. When she got back to her office, she called the Red Queen in an effort to make up with her a bit, but the Queen was having a massage and couldn't be disturbed.

The White Queen, however, was developing some ideas of her own. She wanted a much more elaborate souvenir book for the evening than the one the March Hare was going to print. She told Alice that her projected four hundred guests weren't nearly enough. They ought to have eight hundred to a thousand to honor the Duchess. "That is the *very* least the Duchess deserves," she said. A few days later, the Duchess told Alice that she had given the White Queen her approval to do whatever she felt necessary to make the event a success.

Although Alice wasn't sure how the Chairbirds fit into the Duchess', or the White Queen's, new scheme of things, her principal concern was who would make certain the evening stayed within some kind of budget. If the White Queen was right and four hundred more people than Alice had estimated would buy tickets, any additional expenses could easily be covered. If not, as Alice was almost sure would be the case, the White Queen's extravagant plans would significantly reduce the much-needed profit. In addition, Alice felt that her responsibility as Executive Director included both fiscal control and some sort of overall control.

Alice called the Duchess to express her concerns and to ask who actually had the ultimate responsibility for the evening's fiscal success. The Duchess listened quietly, told Alice she would meet with the White Queen, and would communicate with Alice the next day.

Alice waited and, shortly after noon, a messenger delivered a letter. It was on the Duchess' mauve imperial-sized stationery in an envelope luxuriously lined with silver foil. The letter began, simply, "Alice Dear:".

My subject is the Gala day
And who will lead the crew.
I write to you as President
Though I am victim, too.
And faithful friend, you must believe,
I do remain to you.

The White Queen heard from me today
About your grave concern.
She shares your fears on my behalf
Which I was glad to learn.
She's *your* friend, too, I ought to add.
Her back she will not turn.

But I cannot allow my heart
To rule my pretty head,
And so I send with nervous pen,
This warning off to you.
Though I respect your talent, dear,
My wisdom must win through.

And so again I must repeat
What I have said before.
Our Gala will not e'er succeed
Without a gallant core
Of Chairbirds and committee Birds
And many, many more.

There can be only one to lead,
Someone to give her all,
Who can foresee our every need,
Upon whom all can call,
Who strokes, cajoles and compliments,
Who is, in short, a doll.

In my unbiased view, my dear,
You're simply not the one.
It is my most sincere belief—
And my will *will* be done—
The White Queen is the best to serve
Until the day is won.

Of course, you must be well informed.
The Queen will see to that.
But she will take the Gala reins
And with her you will chat.
She will decide and she will chart
The course and where it's at.

So, Alice dear, I order you
No more to interfere.
I want you to cooperate,
And smile without a tear.
It's onward now and upward now, and
Naught else will I hear.

You asked about the ultimate
Responsibility.
That lies with you and Tweedledum
And, finally, with me.
But now your task's to implement
And do it cheerfully.

The letter was signed, "As ever, with love." Alice sat quietly and read the letter several times before she put it in her drawer and returned to work.

The White Queen went to work with a vengeance, calling a meeting of the Birds to organize them to sell pages in the souvenir book. She hired a designer and printer to produce it. She called Unicorn/Lion Productions, who were organizing the entertainment, and ordered a new dance band, twice the size of the one already engaged. What else she may have done, Alice had no way of knowing, for the White Queen did *not* keep her informed. What Alice knew, she learned accidently.

Three weeks before the Gala, it appeared that the attendance would be, at most, four hundred fifty, rather than the "eight hundred to a thousand" the White Queen had convinced the Duchess she deserved. The Duchess called a meeting with the Red Queen, Tweedledum and Tweedledee and herself, all members of the Board's Executive Committee, and Alice. The Duchess presented her financial estimates for the Gala, and delivered her opi-

nion that, if it was held on the scheduled date, it would be a financial disaster. Alice looked over the estimates and found a simple error in subtraction which caused the gloomy forecast.

"Excuse me," said Alice, "but there's an error."

"There can't be," said the Duchess. "I checked the figures myself."

"But, if you will look at my estimates..." protested Alice.

"I'm not interested in *your* figures," sneered the Duchess.

"Well, I am," said Tweedledee.

"Not on my time," said the Duchess. Tweedledee stared at her and started to tremble. After a moment, he stood up and strode out of the meeting.

When he was gone, the Duchess showed the other two Executive Committee members a draft of a letter she and the White Queen had written. The letter announced that the Gala was being postponed.

"This is utter madness," thought Alice, too tired now to try to interfere further. So the Duchess had her way and the decision was made to reschedule the Gala for the following spring. That would allow enough time for "proper" preparation, and to secure an audience of respectable size.

The next day, Tweedledee came to see Alice. She showed him her income and expense estimates for the evening, and he saw the error the Duchess had made. He telephoned the Duchess but she would not speak to him. Then he called several other Board members but, by the time they agreed that postponement was folly, it was too late. The White Queen had put the letters in the mail.

"You know," Tweedledee said to Alice, "they are going to make you the fall guy for this."

"How can they?" sputtered Alice.

"They will," replied Tweedledee.

Shortly after, the White Queen and Tweedledum, who by then

acknowledged that the postponement was a mistake, came to the office, both screaming and wagging their fingers in Alice's face.

"This is *your* fault, you know. If you'd done your job, we wouldn't be in this mess. You sat there at the meeting not saying a word. How *dare* you not apologize for what you've let us do?"

"Oh dear," Alice sighed to the Cheshire Cat later that afternoon. "It's all so totally insane. We don't have any money to operate between now and then. We'll all be working on the new Gala with no attention to raising other money. And we'll have wasted so much on the cost of postponing, new invitations (the very thought makes me shudder), postage and I don't know what all. I just received a bill from the designer the White Queen hired to do her souvenir book and his design fee alone is half my budget for the *entire* evening—not counting food, of course. And I'm in an awful fix. I can't go on with a President and a Chairman who feel about me as they do. Oh dear," she said again and let her head sink into her arms. When she looked up, the Cat had disappeared without a word.

Chapter 4

Alice knew her situation could only get worse since nothing stays the same. She decided that the air had to be cleared. She composed a letter asking for a vote of confidence, and sent it to the Board. Days went by and there was no response from the Duchess, the White Queen or Tweedledum. Tweedledee did call to tell her he would always be her friend, but that he was resigning from the Board and would not return as long as the Duchess was President. And Mrs. Tweedledee resigned from the Birds.

But other members of the Board called, too, and told Alice they would support her at what would actually be her trial. They told her the Duchess had scheduled it for the very night of the postponed Gala. As the "trial" day approached, Alice's allies met to prepare the case in her defense. Even the White Rabbit said he would return to serve as her counsel. The morning of the trial, the Duchess summoned Alice.

"I do not want," she began, "to say anything tonight which you have not heard in advance. I have, therefore, prepared a list of your virtues which I will read, now to you, and later to them." She handed Alice a sheet of paper. Alice followed the list which had been typed out, word for word, as the Duchess read aloud. It was a familiar recitation of the things Alice knew the Duchess found admirable about her, hard work and the like, and when she was

done, the Duchess said, "Now, of course, I have other concerns which, in all fairness, I must present tonight, but which, you understand, I cannot share with you. However, you may rest assured that I will present a fair case to the Board."

"Were you ever punished?" asked the Duchess, as Alice stood up to leave.

"Only for faults," replied Alice.

"And you were far better for it, too!" said the Duchess triumphantly.

"Yes, but I had actually done the things I was punished for," said Alice. "That makes a difference...or at least it ought to," Alice thought, as she closed the door behind her.

Alice did not attend the trial, but this is how it went:

To start, the Duchess came with ballots all typed out with little boxes to be checked, one "for termination" and one "against." When she tried to pass them out at the beginning of the evening, Mary Ann grabbed all of them and threw them on the floor. When the Duchess tried to pick them up, the White Rabbit told her to get on with her side of the case. So the Duchess read her statement of Alice's virtues, followed by a list twice as long of her transgressions, the gist of which, as everyone knew, was that Alice "took the ball and ran with it."

"But that's what we wanted her to do," said the White Rabbit. "That's what we needed. Now you're using it against her. Overruled." When the White Queen tried to speak, the White Rabbit turned on her and demanded an accounting of how much she had spent so far on the Gala, and what amount she had committed to be spent. She didn't know. The Duchess, priding herself on being so precise with figures, was furious that the person to whom she'd given sole authority had *no* idea of the expenses she'd incurred. So the Duchess began shrieking at the White Queen.

"Silence," shouted the White Rabbit. He looked at Tweedledum.

"What have you got to say for yourself?" he demanded. Tweedledum was so flustered he couldn't say a word.

"I don't understand what's going on here," said the Red Queen. "I thought Alice was on trial, and here you are questioning everyone else."

"Correct," said the Duchess, "and I think we should get on with it."

"Yes," said the Red Queen, "let's have the sentencing."

"We don't have a verdict yet," said the Duchess, ever on the side of proper procedure.

"No, no," said the Red Queen, "sentence first – verdict after. Off with her head!" she screamed.

"Stuff and nonsense!" said Mary Ann.

"Shut up!" cried the Red Queen.

"I won't!" said Mary Ann.

"You will!" said the White Rabbit, and everyone quieted down. Then he turned to the March Hare and said, "Have you anything to say before we consider the verdict?"

The March Hare stood and spoke quietly. "If Alice has committed any crime, it is one of passion, because of her desire to make a success of the Orchestra, and striving for the excellence it deserves. That has always been my understanding of why she is here, yet we seem to be condemning her for these efforts. I must say I was surprised when the Duchess called me this afternoon to ask where we might begin to seek her replacement." He looked at the White Rabbit. "That was a little premature, don't you think?"

The White Rabbit turned to the Duchess. "How could you do the very thing you accuse Alice of? You acted on your own, first by putting the White Queen in charge of the Gala, taking it out of Alice's hands where it belongs. Then you singlehandedly forced postponement. Now you have presumed to give both verdict *and* sentence by starting to seek her replacement!"

"I never heard anyone talk to *any*one like that before," muttered a disgruntled Red Queen.

"I think we've heard enough," said the March Hare. "I think we should call for the verdict now."

The White Rabbit went around the room, starting with him and Mary Ann. Both said, "Not guilty." Tweedledum said, "Guilty," and so did the Red Queen, of course. The Knave said, "Not guilty." The White Queen said, "Guilty," but everyone else said, "Not guilty." The Duchess grew more pale with each passing "not guilty" and, when her turn came, at the very end, she spoke so softly no one could hear her.

"Speak up," said the White Rabbit. "What is your verdict?"

"Not guilty," said the Duchess. She did not look at Tweedledum or at the White Queen but stared stolidly at the White Rabbit. "I move we make the verdict unanimous."

"Second," said the White Rabbit.

"Hear, hear," said the others, except for Tweedledum who said, "I resign!"

"So do I!" said the White Queen.

"Done!" said the White Rabbit, and they all went home.

The next day, the White Queen called Alice, who could not imagine what she would want. "I congratulate you," said the White Queen. "That was quite a political coup. Actually remarkable. I commend you. I really do. I was absolutely floored. A little unsophisticated, perhaps, but the more I've thought about it, the more remarkable it becomes. If you decide to enter politics, let me know. I'll give you some pointers. But, all in all, you have my compliments."

Alice put the telephone down, feeling rather "floored" herself. She spoke with a number of Board members that day, but she was not in touch with the Duchess. When they did speak, there was no mention of the trial. It was as if it had never occurred. "Just as well," thought Alice. With Tweedledum's resignation, she no longer had a Chairman so she had to report exclusively to the Duchess. Their first meeting was on the subject of the ill-fated Gala.

"Alice dear, about the White Queen. What can I tell you? I was just so frightened, you know. I've never been honored before and I so wanted it to be a special moment for me. It just seemed...well, you know...I just didn't know if you could..." Her voice trailed off into silence. Then she recovered. "Now, of course, I know you *can,* and it *should* properly be you. But the Red Queen says she'll resign as co-Chairbird if you have anything to do with it. And, if she goes, Tiger-lily will, too. And there isn't anyone else." The Duchess slumped low in her chair. She was looking very like the victim and not the honoree.

"Further, the Red Queen wants to have complete control of the finances, and doesn't want any of the money to go through the office. I *know,*" she continued as Alice started to speak, "that it's not right, but..."

"Not right!" protested Alice. "My dear Duchess, to give total control over to her is to make the same mistake we made before. Besides," she couldn't resist adding, "what does she know of figures and accounting? She hires people to do all that for her."

48

"I know, I know," replied the Duchess wearily. "But what choice do we have? We must have her name and her work. Without it we are doomed. *I* am doomed. If you see an alternative, please tell me."

Alice could see none and so it was decided. Alice turned the ticket income received from the original Gala over to the Red Queen, along with a complete accounting of where it had come from. And the Red Queen opened a new account at her bank.

The school lectures had been going on for some weeks when the Larkspur appeared at the office one day, in tears. "The Hatter and the Mock Turtle have been at every lecture since you stopped coming," she told Alice between sobs. "The Hatter always sits as close as he can to the front and he glares at me. At first, I didn't mind so much. I was having fun and so were the children but, now, I can't concentrate on anything but his eyes under that stupid hat. It's as if he can see right through me, as if I weren't there at all." And, with that, the Larkspur began to wail.

Alice patted her shoulder. She could easily imagine the effect of the Hatter's forbidding presence. "I'll see to it that he stops coming," she told her.

"How?" choked the Larkspur.

"I'm not quite sure," Alice replied, "but I will."

"It's too late," cried the Larkspur. "I'm sorry, but I can't go on. I just can't face it anymore. Please don't ask me!" Her tears had turned black and blue from her mascara and eyeshadow.

"At least you're through for this week," said Alice. "Will you think about it for a few days and reconsider, if I can insure the Hatter won't bother you again?"

The Larkspur reluctantly agreed to that and said she would call later with an answer.

Alice then telephoned the Hatter. "This is Alice. How soon can you come in? We have a problem and I have to see you immediately."

"Immediately it is, then," replied the Hatter cheerfully.

When the Hatter arrived, Alice told him about the Larkspur's distress. "I don't know what she's talking about," he said. "I've hardly spoken to her."

"You don't need to," said Alice. "Your presence is quite enough and that's got to stop. I don't want you at any more lectures."

"It's *my* project and I'll go to every damn one if I want to," retorted the Hatter.

"No, you won't," said Alice.

"You can't stop me," said the Hatter.

"No, but I can cancel the whole thing."

"You wouldn't!"

"I would! I don't have time for this sort of thing. I did it because it was your project and I thought it would be a good thing to do. I also thought it would be trouble-free. I should have known better," she added under her breath.

The Hatter's demeanor changed and he smiled winningly. "It is. It will be. I'll have a talk with the Larkspur. She misunderstood. I meant her no harm."

"I think it's a little late for that tack," Alice said. "But let's wait and see if she decides to go on, or not."

The Hatter waved to the Mock Turtle in Dinah's office and they left as quickly as they had arrived. The Larkspur did not call. She sent a wire. It contained two words: "I can't."

The lecture schedule had been set for the next several weeks. Canceling was obviously not the best solution, but who would provide the lectures – the Birds? Who would prepare them – the Hatter? Was there time? Would any be available? In Alice's experience, probably not.

She called the Hatter. It was, after all, his idea, not hers. Perhaps he had a solution. He did. He would do them himself. His arguments were persuasive.

"But you must behave yourself," said Alice. She couldn't think of anything else to say.

At first, the lectures went well. Alice spoke with the principals after each lecture and every one voiced approval. She began to relax and, after several days, she stopped telephoning. Then, a principal called her. The Hatter had been rude to the teachers. From another call, Alice learned that the Hatter had made fun of some of the children's questions. From a third, she heard the Hatter had used a few ill-chosen words within earshot of the audience. A parent called to say her child had come home in tears.

Alice was as furious with herself as she was with the Hatter. She should have known. She telephoned the Superintendent of Schools and told him there would be no more lectures. She prepared a list of expenses to date and sent it to the funder, with a check for the balance of the contribution. She called the Hatter to tell him what she had done and why. He hung up before she could finish. "Oh

dear," she said to Dinah, "will it never end?"

During this period, there had been no Council meetings. Alice, of course, had other things on her mind, but Humpty Dumpty had not suggested one either, so there the matter rested until mid-season. It was then that the more active members began to notice that the Orchestra was giving concerts not approved by them. The irate group demanded that Humpty Dumpty call a meeting and, on the appointed evening, Alice and the Duchess met with all of them, including the Mad Hatter.

"Vy must ve read everyting in zuh newspaper?" demanded the Dormouse.

"Why have there been no more auditions, as we agreed at our last meeting?"

"What happened to the Hatter's wonderful project?"

"Where did the money come from for these concerts, and who said that's what it should be spent for?"

"Speaking of money, we've never seen a budget. Who is deciding how much is to be spent for what, anyway?"

"We're spending too much on administration, I can tell you that!"

"Why did Tweedledum and Tweedledee resign from the Board?"

"Why don't we have control over everything, as we used to?"

"The Duchess was supposed to keep Alice under control."

"Some people have to learn their place."

"But vat of zuh children? Ve must haff more concerts for zuh children."

"Not enough is being spent on scholarships. We must insure the future of our Orchestra by providing more scholarships."

Motions were made and never seconded. Seconded motions got lost in discussion. Votes were taken and decisions were finally made. Alice took notes and answered the questions addressed to her. The Duchess, as was often the case when she was in Humpty Dumpty's presence, remained silent.

The Mad Hatter listened to the proceedings without comment. Occasionally, his mouth would quiver as if he were trying to suppress a smile.

"We have to meet with the Board. They have to do as we say."

"If they don't, we'll resign," said Humpty Dumpty.

In the weeks which followed, Alice continued to work under the direction of the Duchess. The White Rabbit was prevailed upon to accept the Chairmanship again, but it was "in name only," as he was still many miles away. Alice and the Duchess spoke to each other daily. Nothing was said about the meeting the Council had demanded.

During the winter, the Walrus had been gravely ill and Alice hoped that he knew nothing of the turmoil of the Orchestra he helped found so many years ago. When he passed away, Alice was very sad. He had been her friend and she felt the loss, although their acquaintance had been brief.

The morning the Walrus died, the Duchess called to tell Alice to send an announcement to the subscribers and donors. "Just in case anyone is out of town," she said. So they agreed on a simple statement, Dinah called Bill and, by noon, the envelopes were in the mail.

The next day, the Crow was on the telephone. "How could you be so thoughtless?" she croaked. "How could you be so crass? Have you no feelings? What will Mrs. Walrus think?!"

"I'm very sorry," said Alice, "but I don't know what you're talking about."

"I'm talking about the postmark on your announcement. It is dated the day *before* the Walrus died."

"Oh dear," said Alice, realizing that, in their haste to mail the envelopes, no one had thought to change the date on the postage meter. "But it's just like the Crow to read the imprint. Who else would bother?" she said with a sigh to Dinah.

Chapter 5

A few days later, Alice received a telephone call.

"Hello, is this Alice?" asked the voice.

"Yes, it is," she replied.

"I'm with the William Company. The Father William Company, actually. FWC, for short. FWC has chosen Wonderland for a series of grants. I've heard excellent things about the Orchestra and I wonder if you'd like to make a proposal."

"Yes, I would," said Alice.

"What do you have in mind?" asked the man from FWC.

"What do *you* have in mind?" countered Alice, feeling a little foolish.

"Well, we thought something unusual. Something you've always wanted to do but couldn't get the money for. Something a bit risky, perhaps."

"Do you," asked Alice, "have any idea of what...uh...level of funding is possible? Is it five thousand or ten...," Alice decided to "go for broke," "or fifty?"

"Oh, more like a hundred," the man answered breezily. "And, if you have a two-year project, maybe more."

"Oh dear," gasped Alice, "could I get back to you?"

"By all means."

Alice sat very quietly. "This is big," she thought, "this is very

big. This is important. This is a *miracle*. I don't believe it. It's not true. It's a joke."

The Caterpillar often telephoned, pretending to be someone else. Alice thought the call could have been from him.

She called to Dinah. "Look in the directory. Is there a Father William Company listed?" Alice held her breath while Dinah thumbed through the pages.

"Yes," Dinah said, "it's on Sunrise Avenue."

"Call them up and see if that man works there."

Dinah did, and they said he did, and Alice said, "Oh dear."

She called the Caterpillar, who came over immediately. He sat and puffed on his pipe as Alice recounted the amazing conversation.

"Well," said Alice, "what do you think? Shall I do it?"

"Yes, *please*," said the Caterpillar.

"But what–what shall we do?"

"More concerts. Unusual concerts. *Fun* concerts. We'll think of something wonderful!" he said, spinning out a long stream of blue smoke.

"You know what's wrong with this, don't you?" said Alice. "The Council will never approve what we want to do. And they'll never agree among themselves on any project one of them might suggest."

"Quite right," said the Caterpillar. "We'll do it ourselves."

And so they did. They created a series of innovative, unusual, slightly risky, and fun concerts for the Orchestra.

Alice told the Cheshire Cat about their idea the next time he appeared.

"What do you think?" asked Alice.

"What do *you* think?" replied the Cat. "You've been right about things so far."

"But it's so risky," said Alice.

"You said that's what the company wants."

"I don't mean that," said Alice, growing impatient. "I mean the Council. I'm risking my head again."

"Hmmm," said the Cat, fading from sight.

Alice called the White Rabbit and told him the whole story.

"You have my complete support. You know that. If you and the Caterpillar agree, that's good enough for me. Get the money first. Questions later," he said to Alice.

"Ever the businessman," thought Alice, hanging up. But he was right. Securing the grant was the most important thing. She wrote up the description for a two-year program, with a budget well over a hundred thousand, and mailed it off to FWC.

After that, Alice turned her attention back to the rescheduled Gala. Once again, she was having trouble with the Red Queen. She did try to please her. She answered her calls promptly and provided her with all the information she asked for—often more than once, since the Red Queen's memory was no longer what it might have been. But very little, if anything, Alice did was acceptable. Inevitably, the Red Queen complained to the Duchess and Alice was summoned to the Duchess' home once again.

"Alice dear, you must know this is as tedious for me as it may be for you. You can't imagine that I enjoy these little sessions but, really, the Red Queen is coming to me with the same concerns Tweedledum had. They can't *both* be wrong, so I must ask you to explain yourself. First, the Red Queen tells me you won't give her the telephone number for Unicorn/Lion Productions. Now they are responsible for the entertainment and she must be able to coordinate with them."

"She must be mistaken," Alice replied. "Why only this morning, I heard Dinah give it to her for a second time. She told Dinah she'd misplaced it."

"And besides, it's *in* the directory," she added to herself.

"Well, I'm glad *that's* straightened out. Now, this is more serious: The Red Queen tells me that, when the money from the first Gala was transferred to her, you withheld some of it."

"Yes," said Alice, "you yourself will recall the amount which the Knave said we could transfer to the operating budget, since it was so badly needed after the postponement. It was his contribution and his decision, and I made a note of it on the itemized list I gave the Red Queen at the time."

"Oh, of course. I'll make a note of it myself. But she also tells me that you refused to show her the first invitation. She tells me she accidentally saw it in your desk drawer and she had to force you to give it to her."

"I'm sorry, but she misunderstood the situation. I have several Gala files in my drawer and I didn't remember exactly which one held the invitation. While I was going through the files, she was

looking over my shoulder and saw it first. I gave it to her at once. Why on earth would I withhold it? She'd seen it before. Practically everyone in town has one." Alice's impatience was getting the best of her.

"I'm also told that you have not given her all of the old invitation lists, which she needs for the new Gala."

"I'm afraid I can't explain that one," answered Alice. "She has copies of every list I had. Now, the White Queen has some lists which I never saw. Perhaps those are what the Red Queen has in mind."

"Perhaps," said the Duchess, "which brings me to the fifth and most serious charge. She says you are not cooperative. This is an all-too-familiar allegation and it makes me heartsick to hear it again."

"My dear Duchess," said Alice, "you know the last thing I want is to cause you concern and I've always heeded your counsel and advice. Do you find me uncooperative?"

"No," answered the Duchess.

"Does the White Rabbit?"

"No," was the reply.

"Is there anyone else besides Tweedledum and the Red Queen...and Humpty Dumpty and the members of the Council..." The Duchess frowned and Alice decided to stop there. "Well, that is quite a few to be sure," she admitted. "But, dear Duchess, I assure you that I will make every extra effort with the Red Queen, and *please* try not to worry about the Gala. It's going to be wonderful. You'll see."

When Alice returned to her office, she called the Red Queen and suggested they have lunch. "You and I *are* working toward the same goal," Alice said. "All we want is a successful evening for the Duchess and for the Orchestra. You are doing such a splendid job, you and Tiger-lily. But we should meet more often and I would so enjoy lunch."

"I don't have time for lunch with you," said the Red Queen.

Despite Alice's problems with the Red Queen, everything was developing nicely for the new Gala. Alice received more testimonials for the Duchess' book; practically everyone she had asked sent one and there were now well over a hundred. Alice also received the requested citations from the City Council, County Board, and the Mayor's and Governor's offices. The patient and generous

March Hare once again volunteered to print the souvenir book. The Duchess' secretary gave Alice photographs of the Duchess with other Wonderland celebrities and Alice asked a locally esteemed writer, who was an old friend of the Duchess', to write a special tribute as an introduction for it.

The Duchess was very pleased with the tribute when Alice showed it to her, and Alice called the author to tell him so. He asked Alice to be sure to tell the Duchess that, if she wanted to make any changes, or shorten it, she was welcome to do so. Unable to reach the Duchess, Alice left the message with her secretary. Not ten minutes later, Alice heard from the Duchess.

"*Change* it?! You've changed it? How dare you? Would you change a symphony by Mozart or a Beethoven sonata? My tribute is as much a work of art and I won't have you change a single word. You change it right back to the way it was!" she shouted.

It was an obvious miscommunication but Alice could see no easy way, in the face of the Duchess' fury, to explain what the message really was. So, when the Duchess paused for breath, she said, "Of course, it will appear exactly as originally written."

The entertainment secured by Unicorn/Lion Productions was stellar, and would be highlighted by the appearance of the internationally famous Rose, who would sing her signature piece with new lyrics by the Dragon-fly, "There's no Duchess like our Duchess." Tiger-lily had persuaded a local perfumery to donate table favors, the table decorations selected promised to be lovely, and the Birds finally rallied themselves and collected a spectacular array of door prizes. The day before, Alice called the hotel to confirm 438 dinners.

Then it was time. The women promenaded in their evening finery, the men in "black tie." The cocktail hour was full of gaiety, the dinner excellent. The Orchestra played brilliantly. The stars shone and the tributes were glowing. Smiles abounded but none was more radiant than the Duchess'. It faded only when she took her place next to the White Rabbit to receive Alice's book of testimonials and to thank the audience. The crowd drew silent as she leafed through a few of the pages and those close to the podium could see the tears in her eyes. Then she closed the book and began to speak.

"Many of you know the arduous road we have travelled to this

special moment. My love and gratitude to all who worked so hard and you who so patiently waited to join me this evening are unending. This is a moment in time I will cherish always and I will be reminded of it every time I open this lovely book, on which so many of you lavished the love in which I bask tonight. You all know what is involved in preparing such an exquisite evening as this, how many must work from morning to night, how intricate are the arrangements. Of those untold numbers, I must, in the interests of time, extend my gratitude to only two: the Red Queen and Tigerlily. They are known to you all, esteemed here in Wonderland for their charm, grace and generosity of spirit. Such evenings as this are not new to them and many would wish they could secure such noble and charitable Chairbirds for their events. But no, this honor fell to me and I am most humbly and sincerely grateful. Thank you all. Good night, and God bless you as He has blessed me tonight."

After that, there was dancing and, after that, Alice went home. Waiting outside her door was the Cheshire Cat.

"Well, it all turned out exactly as you planned and predicted. You should be pleased with yourself," said the Cat.

"I am, I guess," said Alice. "I'm too tired to notice. But I think the Duchess was happy, and I hope we made some money. After all, that's what really counts."

"Yes and no," replied the Cat. "You think about it." With that, he was gone and Alice went inside to bed.

Early the next week, a messenger delivered a very sweet note from the Duchess, thanking Alice for her efforts and, especially, for the testimonial book. But, the following day, the Duchess asked Alice to come to see her. Alice sat in her usual place and the Duchess began to read a list of complaints and questions resulting from the Gala. Although Alice found them tirelessly repetitive, she tried to listen patiently. But when they came to the question of the "missing" money, Alice said, "Oh, what difference does it make? It all goes into the same pot eventually!"

"That is a totally unacceptable answer," retorted the Duchess. "And further, how could you allow the Mock Turtle and the Mad Hatter to be seated near the service door? The Hatter is the Founder! That was unconscionable."

"I had nothing to do with the seating. You know that. The Red Queen and the Seating Committee made those decisions."

"But you are ultimately responsible," said the Duchess. "You should have seen it and corrected it."

"I'm not ultimately responsible for *anything*!" Alice said through clenched teeth.

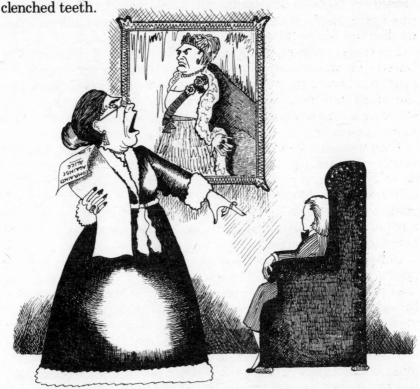

The Duchess ignored, or did not hear her, and continued, "And, finally, your allegation that a multitude of discrepancies is due to the Red Queen's faltering memory is academic. It should be possible to produce paper-detailed-dated-timed memos to support just what did happen if, and when, the Red Queen's memory does fail. I just can't imagine what you've been doing all this time," the Duchess added.

"I did the best I could," said Alice.

To everyone except the Duchess and the Red Queen, the Gala had been an unqualified success, save one vital factor. Alice had been right. With the expenditures wasted on the original Gala,

the net income for the second was not sizable, and the general fund-raising during the year had been virtually nonexistent, with the exception of a few small grants Alice herself had secured. Alice viewed the "bottom line" sadly. After only one year, the Orchestra was again deeply in debt. A bank loan was the only answer. Alice notified the White Rabbit of the situation.

The concert season, however, had been a series of triumphs. The Caterpillar was winning fame as a conductor, not only in Wonderland, but across the country. Guest conducting was becoming a way of life, but he never missed a concert scheduled with his own orchestra, and his enthusiasm for the FWC concerts remained undiminished.

Then the news broke. The project had been approved. It was now necessary to inform the Board and the Council. It was decided to do so by calling a joint meeting of the two factions, the meeting originally requested by the Council. The White Rabbit was delighted by the FWC grant and felt the board could easily overrule any possible objections from the Council. But he and Alice underestimated the situation.

Unbeknownst to them, the Council members had had a busy spring. All of them wanted to wrest control of the Orchestra from the Board, and from Alice. They turned to the Hatter, who now had his own reason for a vendetta. So they had held a number of secret meetings, in the course of which the Hatter developed an alliance with Humpty Dumpty. Alice had suspected something but, when she asked the Duchess, the Duchess said, "Meetings? Oh, no, you must be mistaken. The Council would never meet without me." But the meetings had, indeed, taken place and the Council was well organized. The Board, expecting nothing out of the ordinary, was not. And, at the last moment, the White Rabbit's business prevented his attendance.

The meeting room available was large and, in the center, were two long tables with a much smaller table between them at one end. The Council members were there in force and they sat in a row at one table, with the Hatter and Humpty Dumpty taking the seats nearest the small table.

The few Board members who attended seated themselves at the opposite table. The Duchess sat facing the Hatter and Humpty Dumpty. The chair in the center, at the small table, was left vacant; Alice realized it was intended for her. Everyone was strangely

quiet. The Council whispered among themselves and the Board members eyed each other nervously.

"Let us begin," said Humpty Dumpty loudly, and he whacked his gavel on the table. He nodded to the Carpenter, who sat next to him. The Carpenter stood and began to read:

"The Council has requested this meeting because we are concerned about our Orchestra's future. We disagree with the decisions of the Board and feel those decisions have placed the Orchestra in peril. We want it on the record that we like Alice; however, to give her the authority to run the Orchestra, as she sees fit, against our wishes and without our advice or approval, indicates to us the incompetence of the Board as a whole. What do you know of running an orchestra? What do you know of music and musicians? You are business people. You know about money, and that is all you know. You should be raising money. *We* should be running the Orchestra. And Alice, what does Alice know? Where did she come from? Who brought her here? Why is she *still* here when we have repeatedly asked for her dismissal? She has blatantly ignored our rulings. Her musical judgment has always been suspect. Now it seems she is financially unqualified as well. Thanks to her bungling of the Gala this year, we understand there is no money to pay the Orchestra for the last concert."

Alice looked at the Duchess, who raised her hand to interrupt the Carpenter. "Excuse me," she said, "but I must correct you. Alice did not bungle the Gala."

"Oh," said the Carpenter. "Well, be that as it may, it doesn't change our position. We want Alice out and we want to run the Orchestra. It's as simple as that." He sat down.

With the White Rabbit absent, it fell to the Duchess to respond. She rose slowly to her feet.

"I appreciate your concern," she said quietly, "but we, as a Board, must take issue with much of what you have said. I do not, for myself—as you well know—vouch for Alice's musical credentials. In that, you may be quite correct. In every other way, however, she has done an exemplary job for us and she has the Board's full support. You may not be aware that we evaluated her performance not long ago and she was not found wanting in any respect. Further, we have just been advised that the Orchestra has been selected as one of only five organizations in Wonderland to receive a major grant from the Father William Company. This grant was secured by

Alice herself, in consultation with the White Rabbit and the Caterpillar. That clearly indicates a level of grantsmanship we have never enjoyed before. This is a two-year grant, representing well over one-hundred thousand—"

At this point, the Duchess was drowned out by over thirty voices, all speaking simultaneously:

"What grant?"

"What for?"

"How marvelous!"

"How dare she, without asking us?"

"We won't accept it!"

"Well, what do you know?"

"What does the White Rabbit know?"

"The Caterpillar? What has he got to do with it?"

"We told the Duchess to keep Alice in line."

"She's gone too far this time."

"Wait a minute!" The piercing voice of the Mad Hatter cut through the din, and he turned on Alice. "*What* is this money for?" The room fell silent.

"It is for concerts by the Orchestra. That's what we're in business to do and *that's* what the money's for," replied Alice.

"This grant," said the Duchess, taking the floor again, "places our Orchestra among the elite. We are the only musical organization to receive such a grant. It will be announced at a press conference—" Humpty Dumpty's voice drowned out hers.

"We don't have to accept it," he shouted.

"We *won't* accept it," cried the Carpenter.

"We *will* accept it and there isn't anything you can do about it," declared the March Hare to the opposing table.

A cacophony of voices rose again but Alice was aware only of the Mad Hatter, whose beady eyes were now bearing down on her. "You...you devious, conniving...We'll get you. *I'll* get you. You'll be sorry. You've made the greatest mistake of your life, trying to get around me," he snarled.

"I can't stand this any longer!" Alice screamed. She jumped up and in doing so, overturned the little table with a crash. Everyone else stood then, too, sending pads and pencils and water glasses tumbling in every direction.

"And as for *you*..." Alice turned to the Mad Hatter and took him firmly by the shoulders. Any other time, such an action

would have surprised her, but she was far too angry to be surprised at anything just then. "As for *you*," she repeated, and she began to shake the Hatter. Alice kept shaking and shaking, backward and forward, with all her might. "I'll shake you into a kitten, I will," and, indeed, the Hatter's face grew very small and his eyes very large and, as Alice kept shaking, he grew rounder, and softer, and fatter, and smaller, and Alice realized he really *was* a kitten, after all.

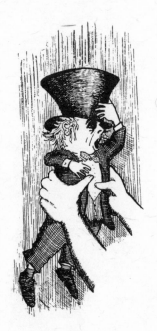

"Oh, Dinah," Alice said, "what a strange dream I've been having. Have I been asleep long?" Dinah just purred, which caused Alice to remark, "If you'd only purr for 'yes' and mew for 'no', or the other way around, it would be so much easier. There's no way to carry on a conversation if you always say the same thing. Oh, well, I hope you had a nice nap. Was I in your dreams? You were in mine. You were the most wonderful secretary, you know."

Alice picked up the book which had slid off her lap, tucked Dinah into the basket and started for home. The sun was beginning to set and the sky was turning the deep blue it does when the sun is gone but still glows in the west.

On her way out of the park, Alice stumbled but caught herself before she fell. When she looked down to see what had caused her to trip, she saw it was a rabbit hole. "How very odd," she thought. "I've never seen a rabbit in the park before. Squirrels, of course, but never a rabbit."

Alice shivered in the autumn evening and hurried on.